Agosto 1.997

Querida Mami,

*Espero que te guste este libro.
Pense en ti cuando
lo ví.*

*Con mucho cariño
Ampelita*

NEW

YORK

DOGS

Photographs by
Andrea Mohin

Foreword by
Vicki Hearne

Captions by
Jack Robertiello

CHRONICLE BOOKS
SAN FRANCISCO

Acknowledgements

My thanks to every dog I photographed and their patient owners, and to the many people who helped me along the way with advice, assistance, and support. Special thanks to Hal Akoa, Marge Anders, Barbara Austin, Dennis Blachut, Mark Bussell, David Cantor, Elyse Cheney, Kit Combs, Fred Conrad, John Contino, Donna D'Agostino, Leslie Day, Suzanne DeChillo, Jim Estrin, Gary Fabiano, Tyril Firth, Angel Franco, Jim Gorham, Anya Grohs, Kevin Hannafin, Chester Higgins, Jr., Peter C. Jones, Edward Keating, Suzanne Kreuz, Evan Kriss, Sara Krulwich, Cristyne Lategano, Nancy Lee, Andrew Lichtenstein, Jesse McKinley, Neeti Madan, Barbara Mancuso, Chris Maynard, Marilyn Mode, Beverly Ornstein, Frances Roberts, Linda Rosier, Ben Russell, Kathy Ryan, Marcos Santos, Howard Schatz, Audra Schebler, Charlotte Sheedy, Karen Silver, David Stein, Edna Suarez, Bob Vissicchio, Nancy Weinstock, Sara Whalen, Jackie Woodson, Ira Wunder, and Jim Zivic.

(Opposite page) Professor Oliver Hollywood climbing a tree, Prospect Park, Brooklyn (Labrador mix)

For Odessa, Harry, Shadow, Buddy, Domino, Molly, Jake, Dodger . . . and Jack, the stray who followed me all the way to New York.

Printed in Hong Kong.

Library of Congress Cataloging-in-Publication Data:

Mohin, Andrea.

 New York Dogs / photographs by Andrea Mohin; foreword by Vicki Hearne; captions by Jack Robertiello.

 p. cm.

 ISBN 0-8118-1658-3 (hc)

1. Photography of dogs. 2. Dogs—New York—Pictorial works.

I. Robertiello, Jack. II. Title.

TR729.D6M64 1997

779' .32'092—dc20 96–35980

 CIP

Book and cover design: Jim Christie

Distributed in Canada by Raincoast Books,

8680 Cambie Street

Vancouver, B.C. V6P 6M9

10 9 8 7 6 5 4 3 2 1

Chronicle Books

85 Second Street

San Francisco, CA 94105

Web Site: www.chronbooks.com

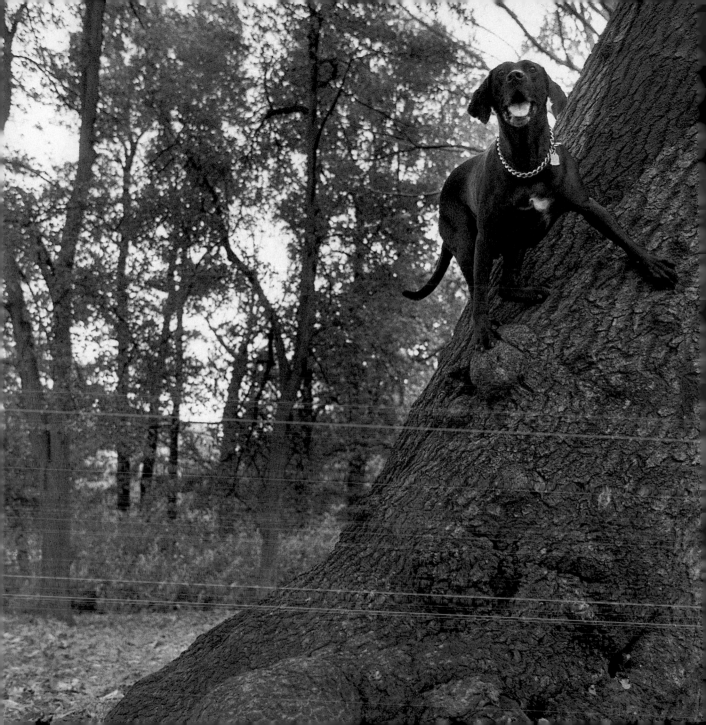

zeus

Evidence recovery training, NYPD
Canine Unit, Queens (German
shepherd)

Zeus, officially ranked a detective
in the NYPD, is an expert tracker,
and he found many victims in the
wreckage of the bombed-out
Oklahoma City federal building in
1995. He is demonstrating how to
handle one particular type of
evidence.

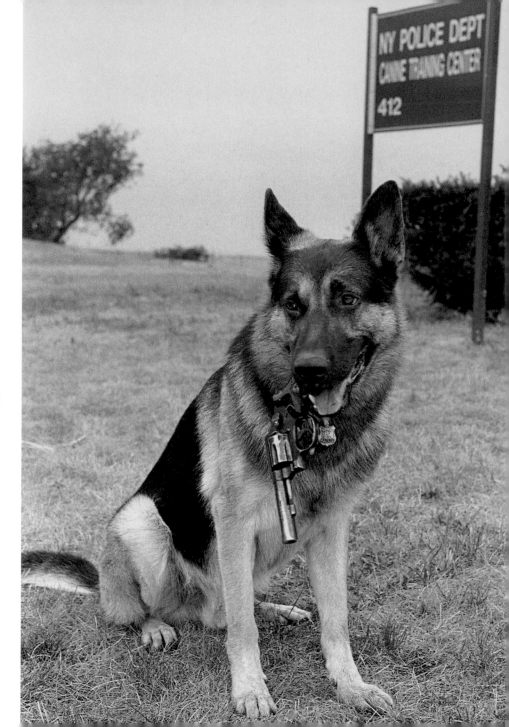

foreword by vicki hearne

There is a belief bruited about that it is "unfair" to keep a dog in New York City. But while it's true often enough so that we should take notice—dogs are neglected in New York—it doesn't happen more often there than anywhere else. Indeed, the form of neglect that consists of just opening the door and letting the dog loose, instead of walking him or her, is much easier in the country than in the city. I suspect that it is the owner, not the dog, who is most often the object of worry when people fret over dogs in the city—or else one would hear more of the suburban and country dangers of being bitten by rabid skunks, hit by a car (yes, there are cars even in the country), or captured and destroyed, sometimes with interim mistreatment, by the dog warden, canine control officer, or whatever other form of humane cop is handy.

Andrea Mohin's dog photographs are not coy about the harsh surfaces of New York, both literal and figurative. The lens does not blur the hard, uneven, rocky streets. In the photograph of Geraldine and Julie taking turns getting water from a fire hydrant in Greenwich Village, you can feel the sharp pebbled heat coming up through the ground as well as the blissful taste of the water. These photographs do not lie about the complexity and discomfort of the city, but their central topic is the good life of a New York dog, the 1,001 reasons it's lucky to live in one of the most dog-loving towns on the planet.

These photographs celebrate dogs who work and function in the city or are simply living rich emotional lives. Some of them are enjoying a leisurely hour, like Blackjack the Dalmatian, whom we see riding home in a cab from a stroll in Central Park. Some, like the two "negative Dalmatians" all dressed up for Halloween, are participating in human activities of which they probably understand little—though most dogs do grasp the concept of a party day. Others are serving justice, like Zeus, a canine who demonstrates evidence recovery.

There are a few dogs pictured wearing clothes. Sometimes the clothes are a simple practical matter, as in the case of Princess and her Michael on Christmas morning. Other clothes are costumes and may look silly or even, to some, exploitative—It has become fashionable in certain well-coiffed circles to protest clothes on animals. However, the dogs seem to be enjoying themselves, and this makes sense

because in order to get a costume to fit a dog and to get it on, you have to spend a lot of time with the dog, expanding your mutual communication skills, and such an experience is liable to make a dog to feel cared for when the costume comes out. My pit bull Missy feels the cold keenly, so I made her a sherpa fleece jacket and a polar fleece sweater to go under it last winter. She wasn't pleased at first, but then she thought the measuring process was funny, and once she learned that the fleece meant warmth, which in turn meant comfort on a walk or during the few work sessions last winter's storms allowed us, she began dragging it to me. I'll have to make another this winter; she has grown, but she still looks entrancing in her sherpa.

The most fetching photograph in here of a clothed dog is the bulldog Hercules, who for the occasion of Halloween is wearing a handsome plaid coat and a deerstalker. So handsome indeed is his outfit that I would advise him to think of it as three-season wear, or at least two.

Still, my favorite clothed dog is Princess, wearing a thick cozy sweater and being hugged by her owner, Michael, himself then homeless. It is my favorite in part because the streets, except for Michael and Princess, are empty, as though these two were the only viable forms of civilization left on Christmas day, and I have known situations in which a person and his or her dog were the cornerstones of local community and culture. And with Michael and Princess it is easier to see what is more subtly true of all the decorated dogs—clothes and decorations are a way of caring for the dog, of making the dog your own and of belonging to the dog.

New York is a quintessentially human artifact. Hence, people who own or have business with dogs have to adjust to the city. This, plus the fact that the dogs themselves are capable of contented and even joyful adjustments to New York, means that not only is a dog in New York a human artifact, but also a human who owns a dog in New York is at least as deeply a dog artifact. What Mohin's pictures show, over and over, is dogs and New Yorkers cooperating together equally. (This is the way dogs control us, by the way, by appearing to be infinitely cooperative but actually only being so when we get it at least to some extent right.)

New York is thus, for its inhabitants and for anyone observing the city and its dogs, a dog lover's town—a town whose landscape is formed by dogs. You can't see them from the New Jersey Turnpike, but you can see them, certainly, on every New York street I've ever been on or driven through. And if you look for them, as Mohin does, you become alert to other charms, such as Cornelius Patrick Byrne's carriage horses and the dog, Maura O'Hara, who helps keep them in line, spending the rest of her time as we see her here, greedily splayed out, absorbing every bit of comfort the world has to offer. And a dog with such serious duties has earned it.

New Yorkers who are artifacts of dogs? Or, at least, a New York that is an artifact of its dogs? There aren't as many bars as there should be in this country that include someone like Kiko, leaning on his elbows at the window, watching New York go by, and thereby forming that bit of New York: that which Kiko watches.

Few cities port Dalmatians home in the backs of taxicabs. And few dogs are as sophisticated as New York dogs. Walking with a dog walker, for example, is something a dog has to learn, to learn with other dogs, and the fans of leashes coming from a dog walker's hand is as emphatically eye-catching a shape as most architecture. The effect both of New York's dogs and of this book is a rounding of some of the uncivilized edges of the city, and a sharpening of the focus that allows us to see New York, its people and its dogs each in their glory.

picadilly

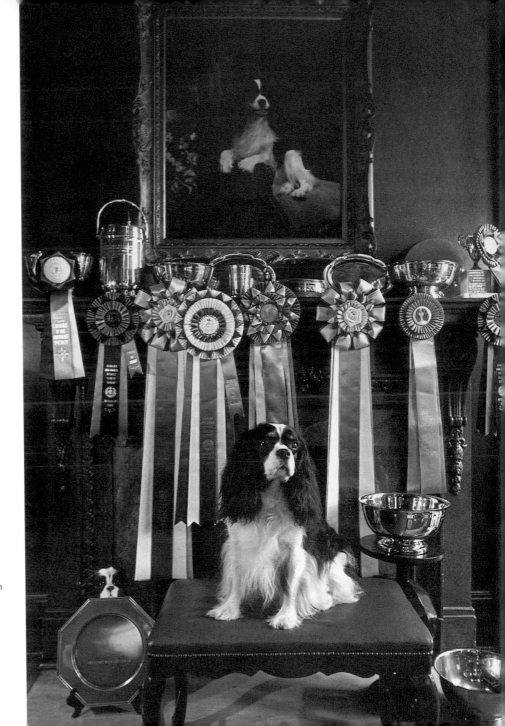

Upper East Side (Cavalier King
Charles spaniel)

The most titled Cavalier King
Charles spaniel in America,
Picadilly posed in his penthouse in
front of a few of his honors and a
commissioned oil portrait.

introduction by andrea mohin

"Long walks in the park, lots of friends, playing ball on the weekends. Does your dog have a better social life than you?"

These words, from an ad I saw in the subway, reflect what many New Yorkers know: rather than being an inhospitable town of concrete canyons, New York can offer canines a full and happy life. Some dogs have real jobs they report to each day. Some have friends all over town and busy social schedules. Others preside over their neighborhood streets, and some ride to Central Park in taxicabs. New York dogs swim in the ocean, lounge at sidewalk cafes, and generally experience urban life in a way very similar to many of the city's human inhabitants.

New York has a long history of appreciation of dogs. The American Society for the Prevention of Cruelty to Animals was founded in New York City at the turn of the century, and the preeminent dog show in the country, the Westminster Kennel Club, has been exhibiting purebreds in New York for 120 years. The city currently has a system of dog runs in the parks (except Central Park, oddly) that are well cared for by a large number of users. There's even a private dog run with a long waiting list.

When I first moved to New York, I believed the myth about city life being unsuitable for dogs, yet so many New Yorkers seemed to keep them as pets, and for the most part the dogs seemed happy and healthy. Though I'd lived in several large cities, I couldn't remember seeing so many dogs on the streets, in the parks, and in just about every social situation. I soon began to realize how much New Yorkers loved their animals and how these dog owners had carved out their own place in the city.

These "dog people," in whose number I now proudly count myself, have established intricate social networks through their dogs, networks that provide an anchor in what can sometimes be a lonely metropolis. These ad hoc groups provide an informal support system that helps dog owners navigate life in the city. Some groups arrange play dates so that their dogs can make friends. I've even heard of dogs invited for a weekend in the country without their owners. It's an additional responsibility and sometimes a hassle, but ownership of a dog in the big city has great rewards.

I learned all of this firsthand after I found my first dog, Odessa. While on an assignment in Brighton Beach, Brooklyn, I noticed a small black shape under a bench on the boardwalk. On closer inspection, I found a small abandoned puppy with injured paws. She had been under the bench for a couple of days, according to the children who had gathered around but were afraid to get close. After I gave her some water, and called my husband and my assignment editor, I settled her in the backseat of my car, surrounded by cameras. She promptly threw up—but I will always remember the children cheering as we drove away.

Afterward, I began to notice the incredible number of strays wandering the street. (New York has a well-meaning but overburdened shelter system and no spay/neuter program.) Like so many city dwellers, I have sometimes worn blinders. Photojournalism has always provided me with a tenuous yet comfortable distance between myself and the pain I occasionally document. Yet, the protection of the lens has never been enough to inure me to the suffering of innocents. After I took in my second dog, Buddy, who was found running down the middle of Flatbush Avenue, I began to carry dog food in my trunk. I have since picked up a handful of dogs on my travels around New York.

I soon learned about a wonderful sanctuary just outside the city in Middletown, New York, called Pets Alive that cares for and places the city's castoffs. As a result, the idea for this book was born, and a percentage of my proceeds are being donated to Pets Alive. (One of Pets Alive's success stories, Jai, appears on page 52.)

With my newfound awareness, I have discovered that there are a multitude of ways dogs and their owners have found to conform to, thwart, and generally enjoy New York life. Learning to swim, riding a bike, rolling in grass, catching snowballs, climbing trees—these are hardly the urban experiences one would normally expect for a dog living in an apartment.

The one thing I've always admired about dogs is how they live in the moment. Perhaps because their lives are so short, they have to experience everything now. It helps explain their sudden compulsions and fugues, their excitability and soulfulness.

With a few exceptions, all these images were made between the fall of '95 and the summer of '96. Since that time three of the dogs have died. These fleeting lives and the companionship they give us led me to try and capture their spirit. I hope that, without condescension, I've allowed the dogs to speak for themselves through my photographs.

Max, South Street Seaport

(Labrador mix)

Max is the unofficial mayor of the
historic seaport near the Brooklyn
Bridge, where he lives aboard a
schooner. He's a seasoned salt:
once, during a sudden gale, Max
pitched overboard. Spotting his
owner's searchlight from the dark-
ened sea, Max struggled back to
the boat after fifteen minutes in
the water.

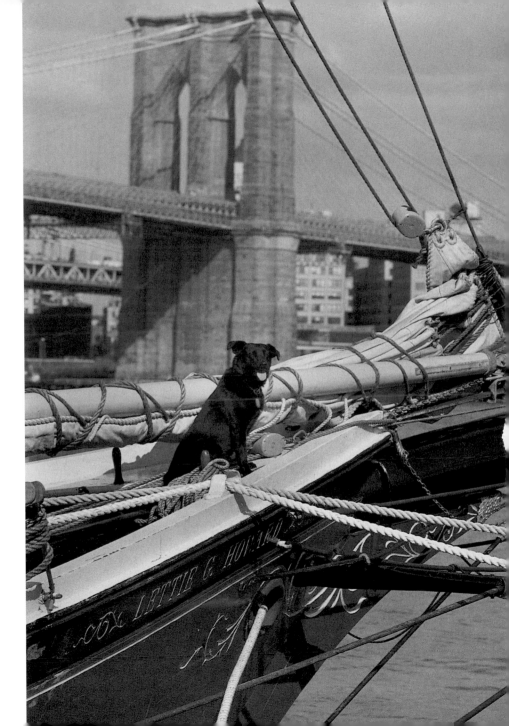

max

quola and pikaso

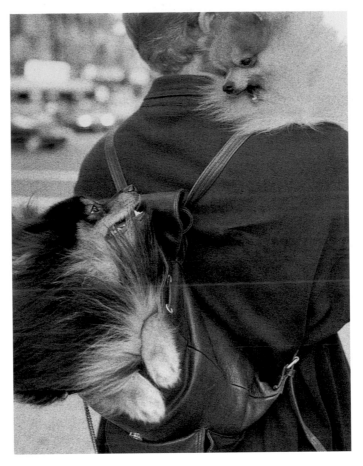

Times Square (Pomeranians)

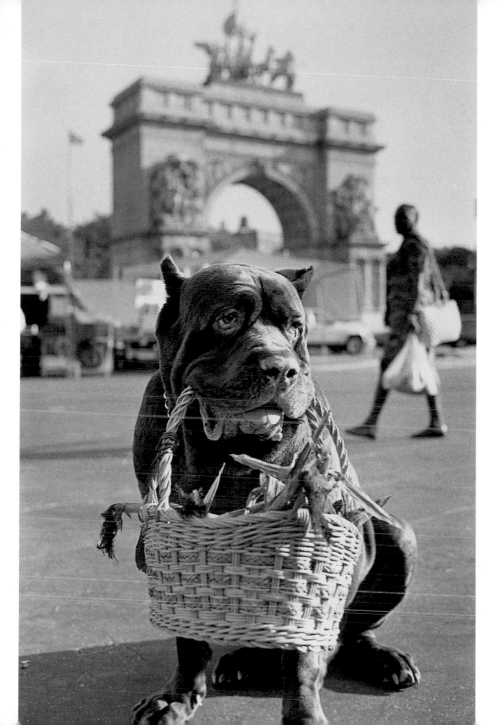

blue

Farmers' Market, Brooklyn
(Neupolitan mastiff)

Blue is well known throughout
the neighborhood for his grocery
shopping skills. Once the basket
is full, he eagerly waits to carry
his load for the twelve blocks to
his home.

dancer

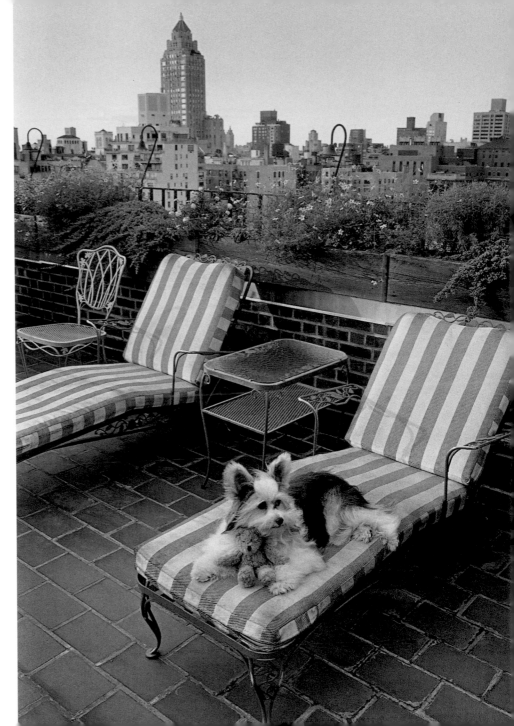

Dancer with "Teddy," Upper
East Side penthouse (Chinese
Crested Powderpuff)

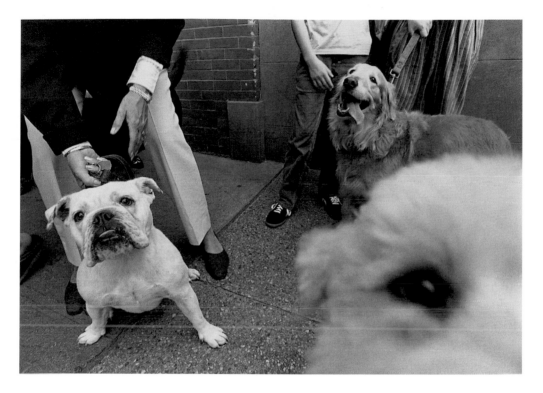

Emily, Howdy, and Tugger, The
Corner Bookstore, Madison Avenue
(English bulldog, Golden retriever,
Wheaten terrier)

emily, howdy, and tugger

olive wants to fly

East River Park (bullterrier)

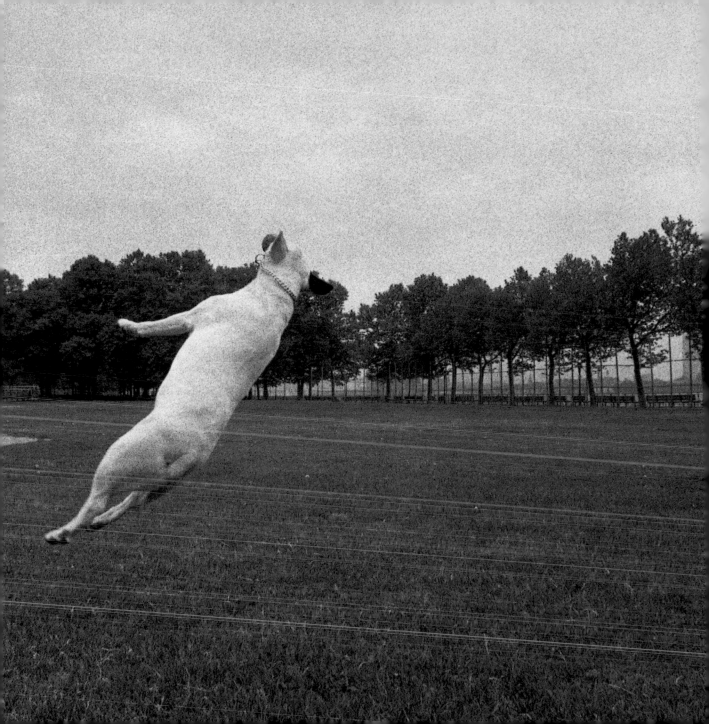

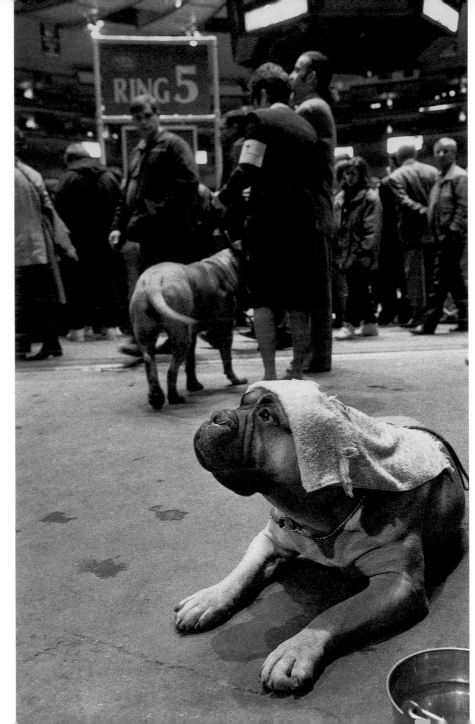

Madison Square Garden

(bullmastiff)

Moments after taking this
breather, Fetching Freida won
Best of Breed among bullmastiffs
at the 1996 Westminster Kennel
Club show. She promptly retired.

freida

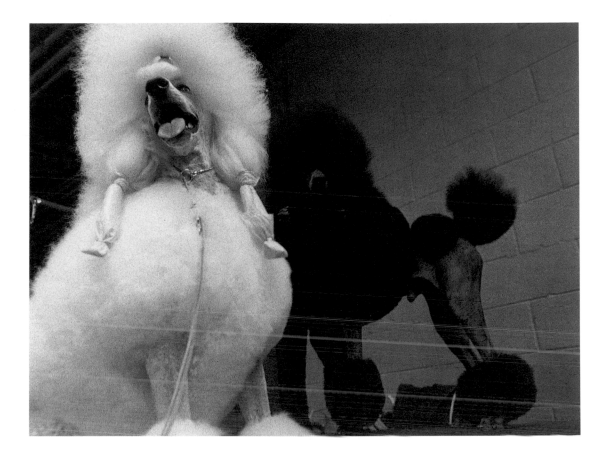

Primped poodles, backstage groom-
ing area, 1996 Westminster Kennel
Club Show, Madison Square Garden
(standard poodles)

goalie

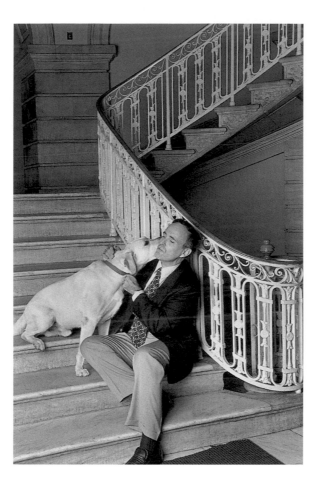

His Honor Mayor Rudolph W.

Giuliani and Goalie, City Hall

(yellow Labrador retriever)

rocky

Dennis Blachut Studios, Fashion
District (mix)

Rocky, a professional model with
the Dawn Animal Agency, was
unwanted and abandoned before
he became a model and actor.
His owner donates all he earns to
a sanctuary for animals.

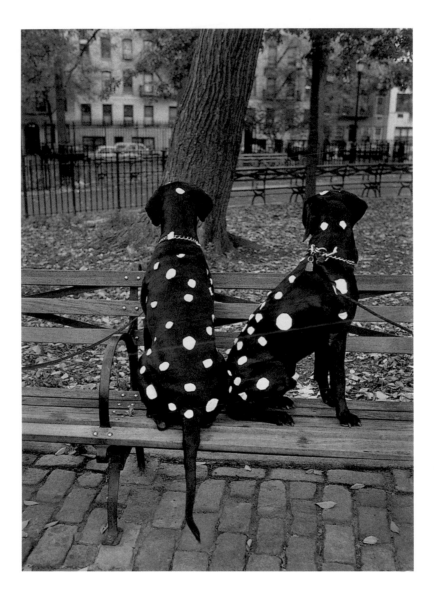

pearl and brunner

Pearl and Brunner as reverse

Dalmatians (mix)

Halloween costume contest,

Tompkins Square Park

barley

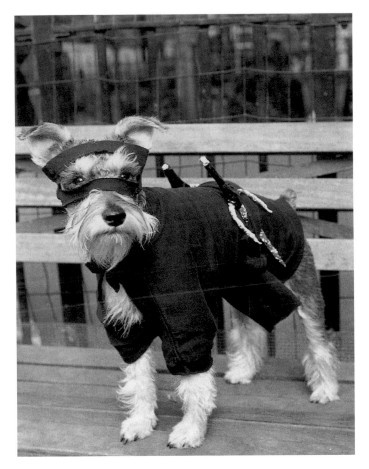

Barley as the Ninja (miniature
schnauzer) Halloween costume
contest, Tompkins Square Park

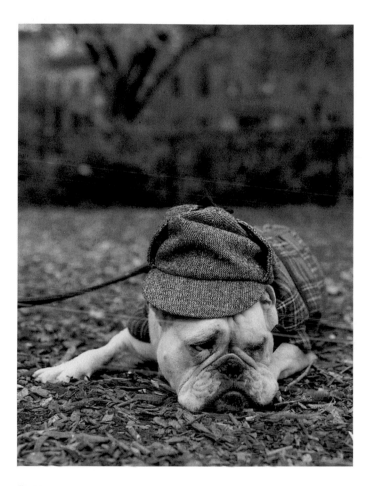

hercules

Hercules as Sherlock Holmes
(English bulldog)
Halloween costume contest,
Tompkins Square Park

lucy belle

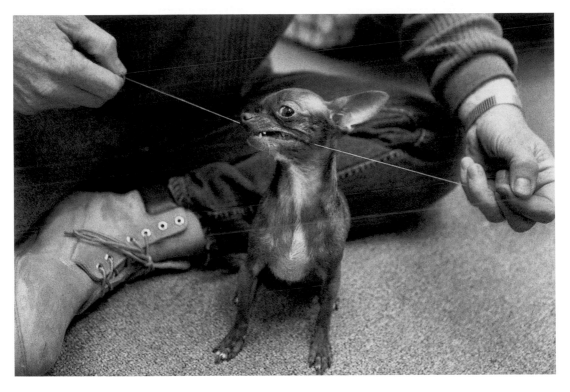

Lucy Belle loves to floss, Lower

East Side (miniature Chihuahua)

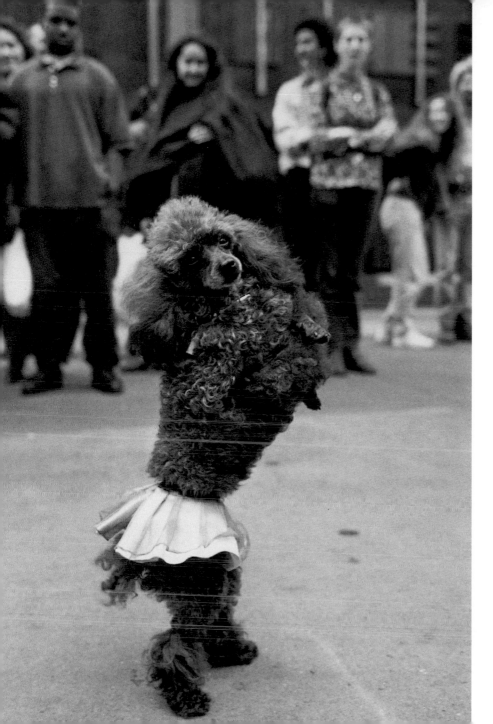

Broadway (miniature poodle)

Inky traveled through Europe as part of a Moscow circus troupe before landing on the sidewalks of New York, where she passes the hat after every impromptu show.

inky

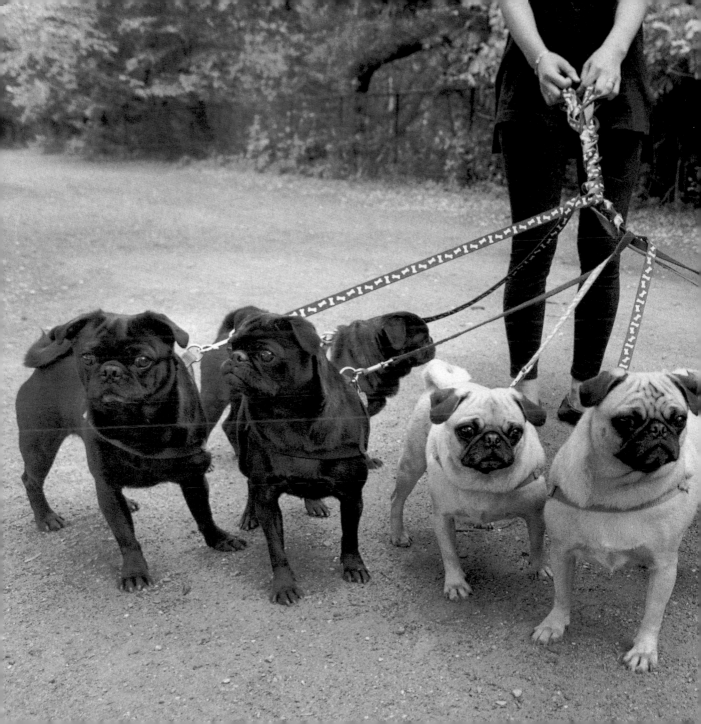

pug family

Pug family promenade, Central Park

(pugs)

Tavern on the Green buffet, Central Park (English bulldog)

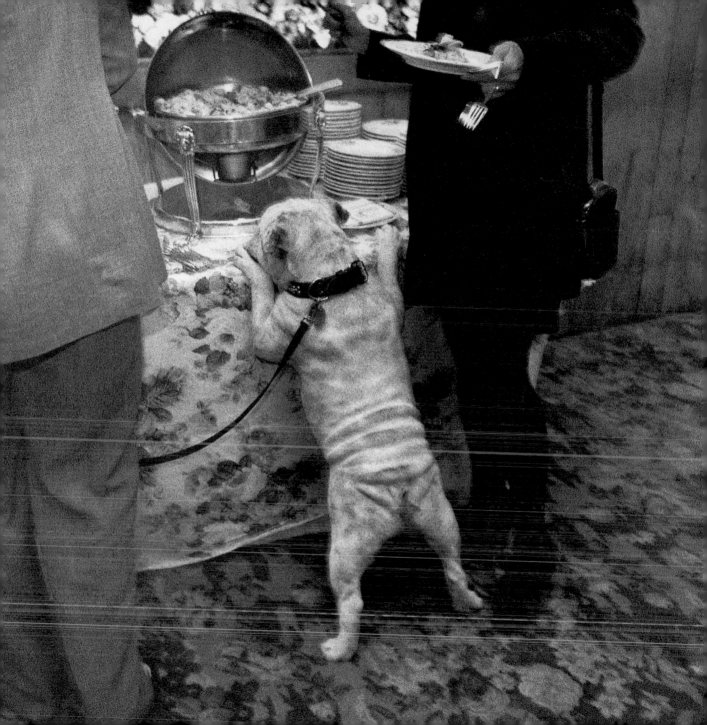

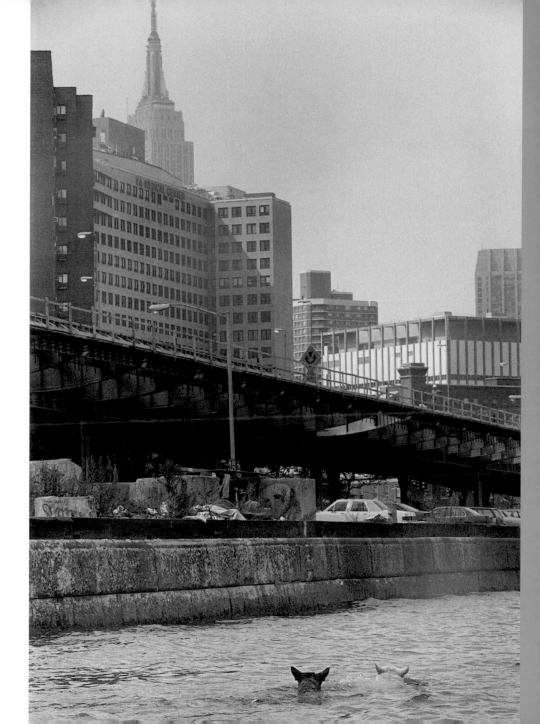

Tulip and Popeye, East
River (shepherd mixes)

tulip and popeye

geraldine and julie

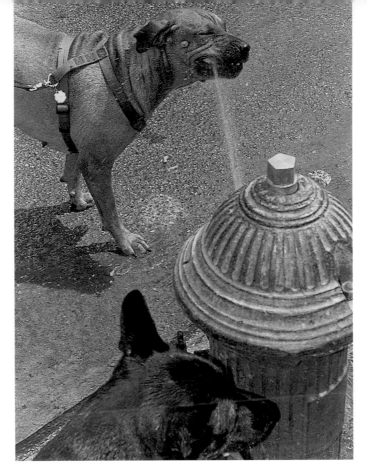

Hydrant's revenge? (Mastiff mix
and Labrador retriever mix)

Geraldine and Julie were wild
teenage girls when their owner
rescued them from a West Side
pier. On a walk one hot summer,
they insisted on a detour to this
open hydrant, where they attacked
the stream of water with leaps
and snapping jaws.

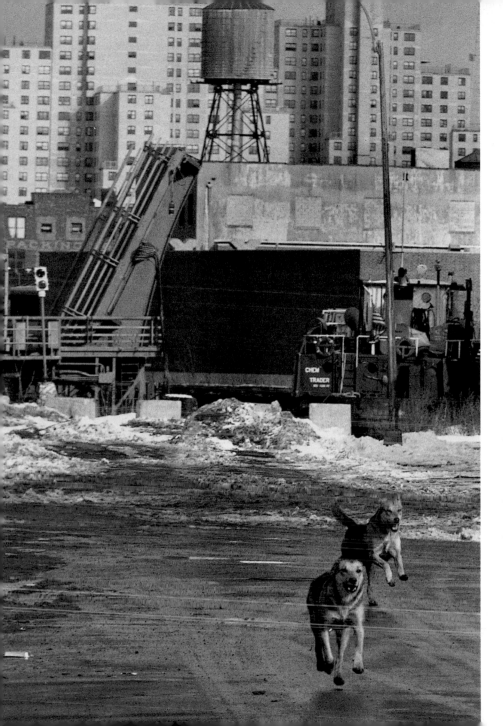

princess and duke

Princess and Duke, Gowanus
Canal, Brooklyn (mix)

When the drawbridge opens for a
tugboat to pass, its signal bell
starts the dog race.

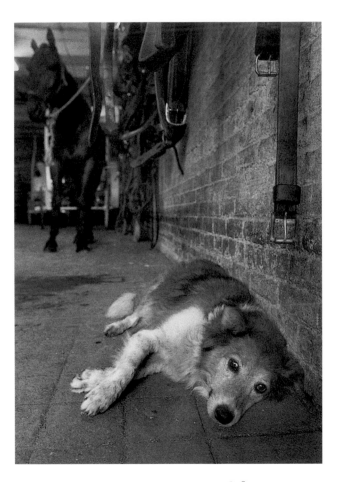

maura o'hara

Maura O'Hara, "stable dog,"

Cornelius Patrick Byrne

Stables, Hell's Kitchen (mix)

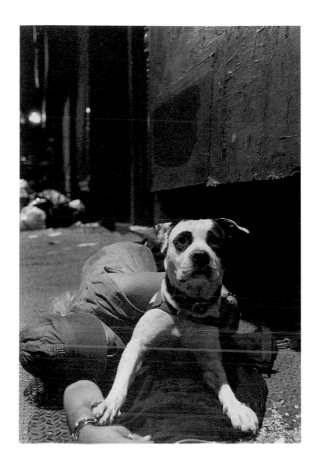

Street Guardian, Lower East
Side (American Staffordshire
terrier)

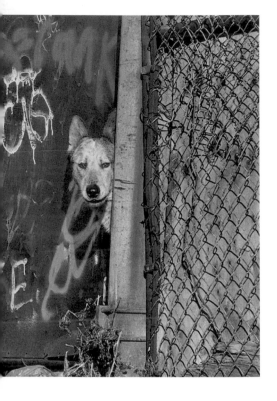

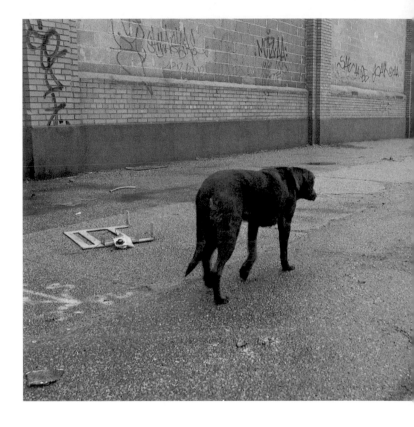

Guard dog, Brooklyn waterfront

(mix)

Stray, Industry City, New York

Harbor, Brooklyn (mix)

Yard dog, Gowanus Canal,

Brooklyn (mix)

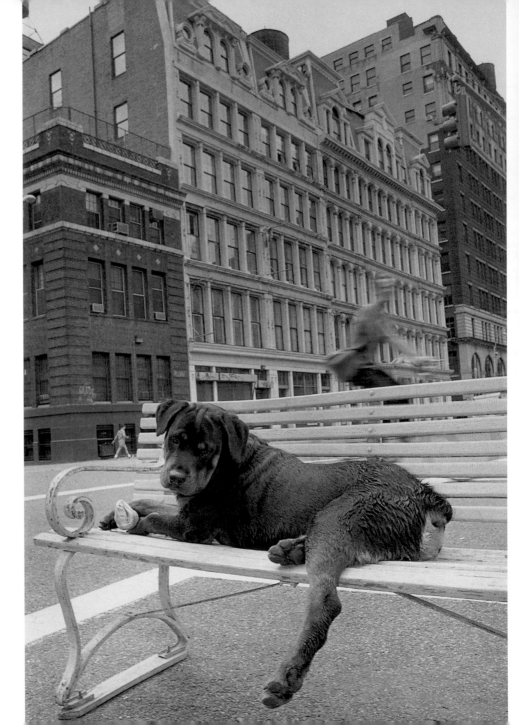

3D's beefcake pose, The Small
Furniture Store, Lafayette
Street (rottweiler)

3 D

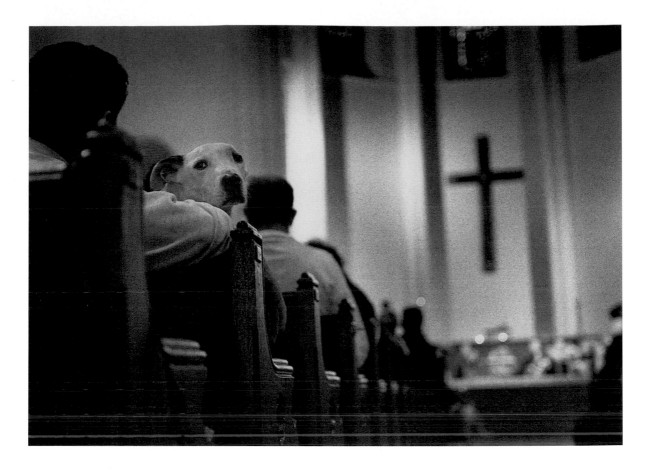

St. George's Episcopal Church,
Gramercy Park (pit bull mix)

Far from his days as a stray, Hot
Rod was one of the quieter congre-
gants during his first formal reli-
gious experience at a St. Francis
day blessing of the animals.

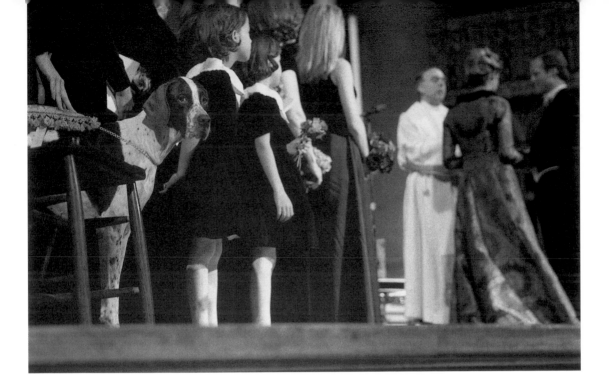

grushenka

St. John the Divine Cathedral,
Harlem (English pointer)

As the ring bearer at her mistress'
wedding, Grushenka slipped her
velvet leash during the procession,
but calmed all fears by regally
taking her place on the altar
among the wedding party.

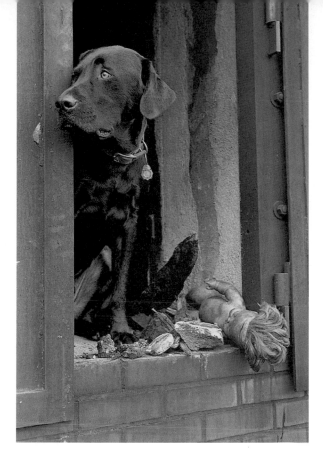

Fire Marshall Fred, New York
Fire Department Arson
Investigator (black Labrador
retriever)

fred

kiko

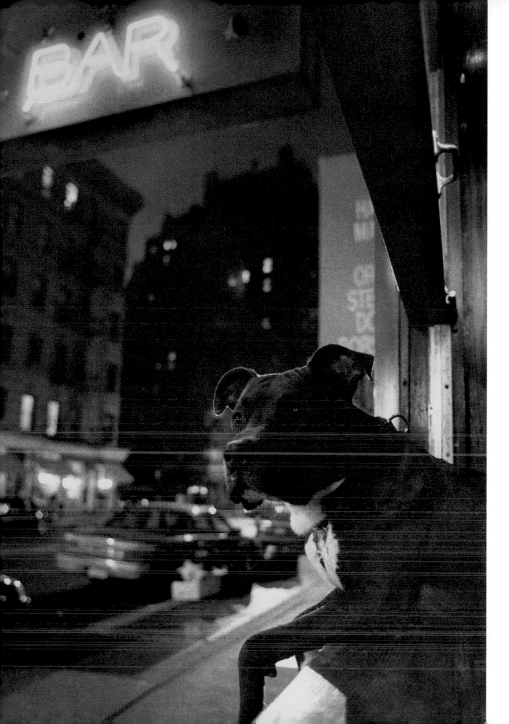

Greenwich Village

(American Staffordshire terrier)

Kiko has been a fixture at
Johnny's Bar since, as a teething
pup, he crunched his first plastic
ashtray. Only fetching females
disturb his bar stool reveries at
the saloon's window.

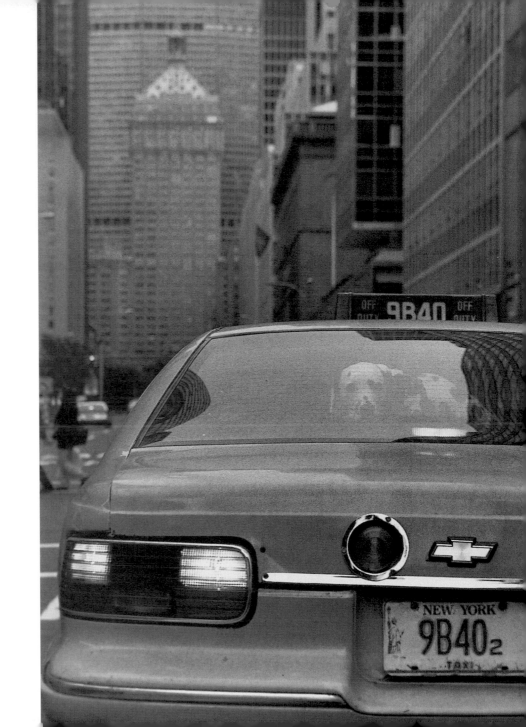

(Right) Park Avenue passenger, midtown Manhattan (dalmatian)

(Opposite page) Sacha and Prancer, ASPCA Walkathon, Central Park (left: Russian wolfhound, right: greyhound mix)

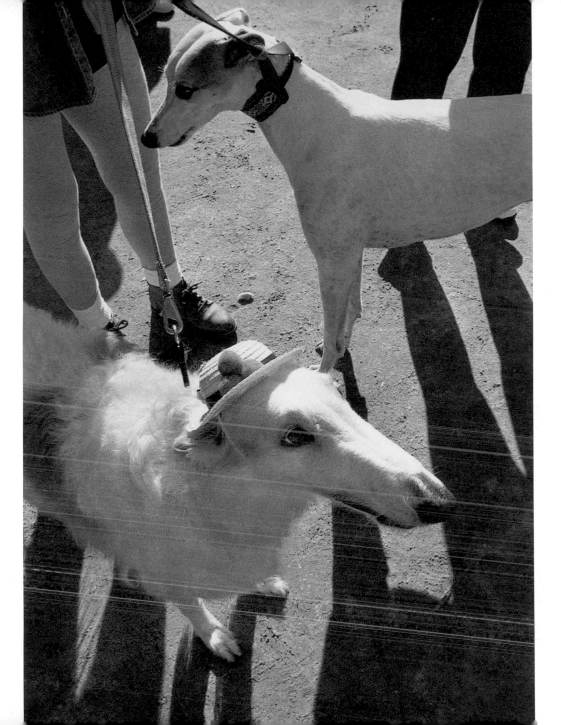

sacha and prancer

orvis

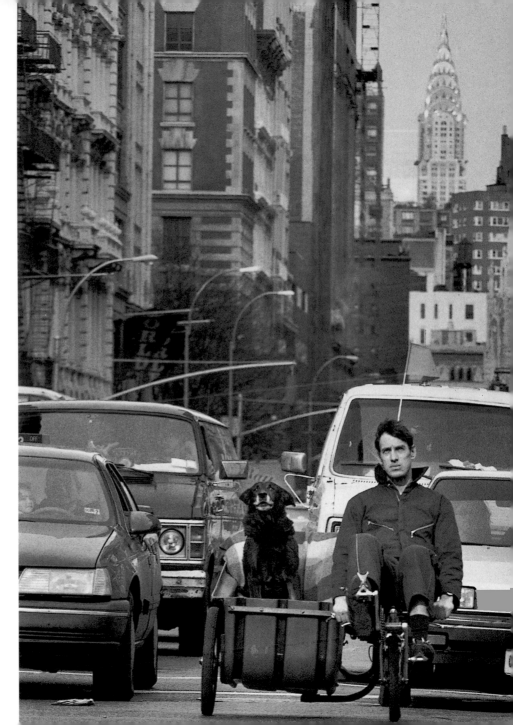

Soho (mix)

Orvis enjoys traveling around
town in this unorthodox fashion,
but if his owner, George, pedals
uphill too slowly, Orvis jumps
out to run alongside.

walt

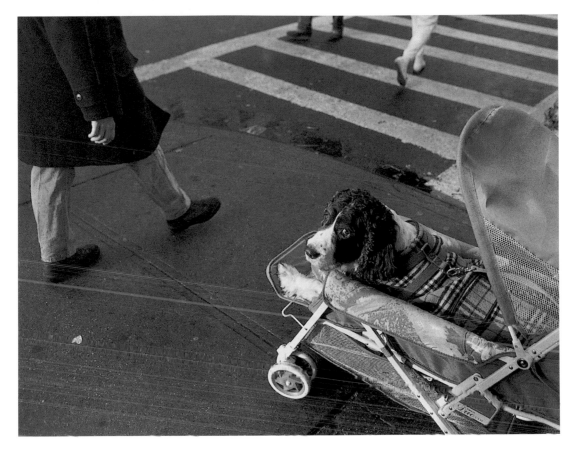

Walt's trip to the park, Third
Avenue, Manhattan (Springer
spaniel)

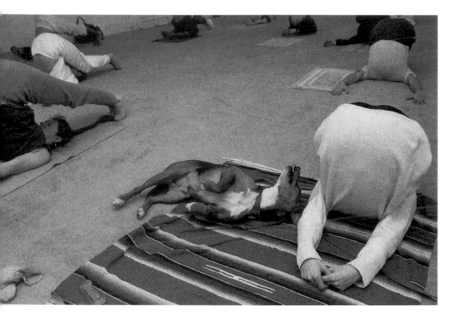

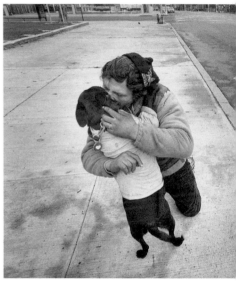

Jai, Kundalini Yoga Center,
Downtown (beagle mix)

Michael and Princess, Christmas
morning, 1994, Chelsea (Labrador
mix)

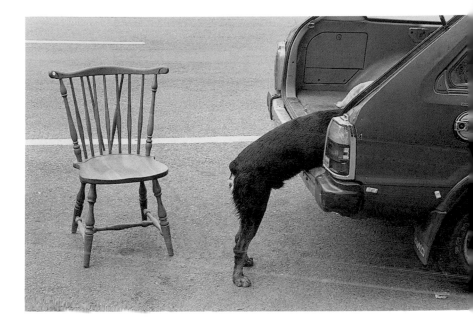

Loading zone, Greenwich Village

(rottweiler)

samson (deceased)

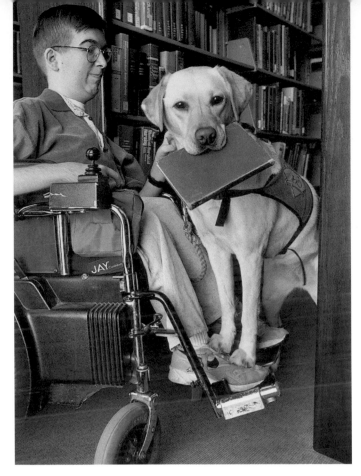

Bobst Library, New York
University (yellow Labrador
retriever)

Wherever undergrad John Stucki
goes, Belle is at his side. A certi-
fied Canine Companion for
Independence (CCI), Belle opens
doors, turns on lights, and pushes
elevator buttons for him. She
knows more than 60 commands.

belle

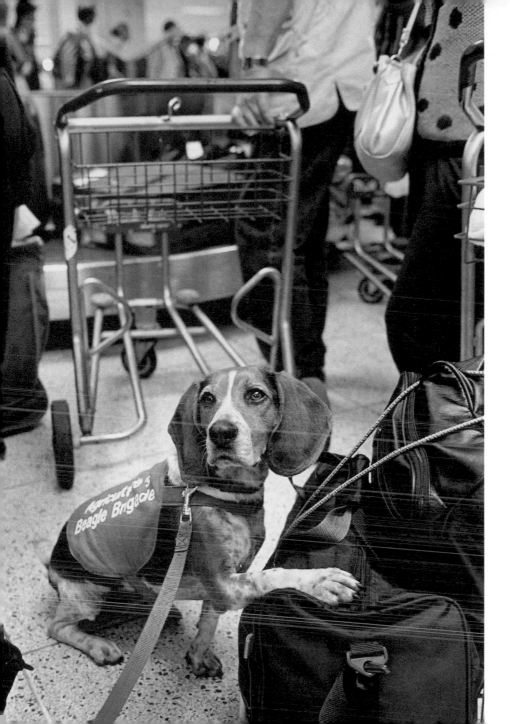

coffee

JFK International Airport
(beagle)

Coffee lives and works at the air-
port, sniffing luggage for hidden
agricultural products. While other
dogs on the USDA's "Beagle
Brigade" sit to alert their handler
of contraband, she's improved her
skills by indicating the "hit" with
her paw. In this case it was a for-
eign apple.

sally

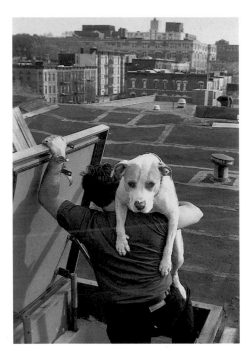

John carrying Sally up to the roof
to visit the tar beach, Park Slope,
Brooklyn (American Staffordshire
terrier)

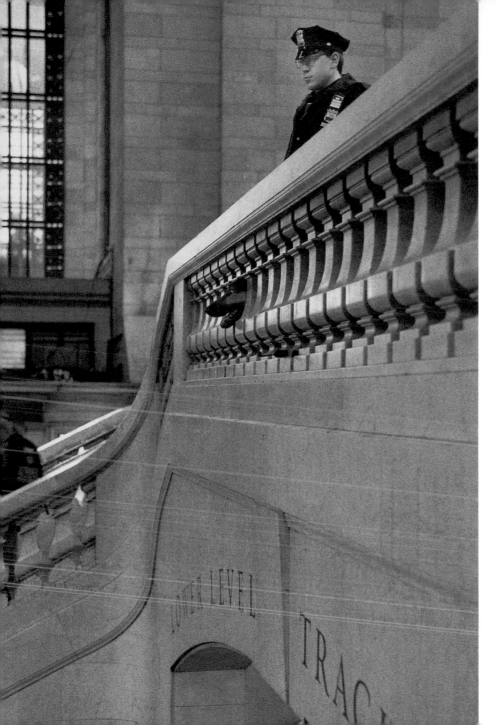

rick

Rick and Officer James Viviani,
MetroNorth Canine Unit, Grand
Central Station (German shep-
herd)

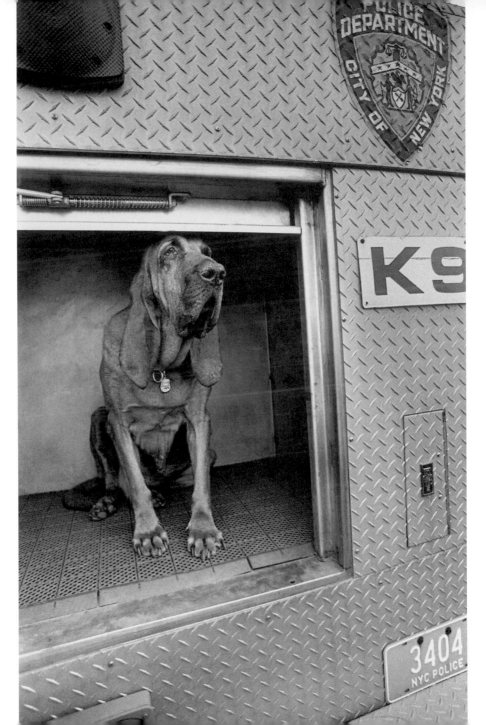

tracker

Tracker, NYPD Canine Unit,
Queens (bloodhound)

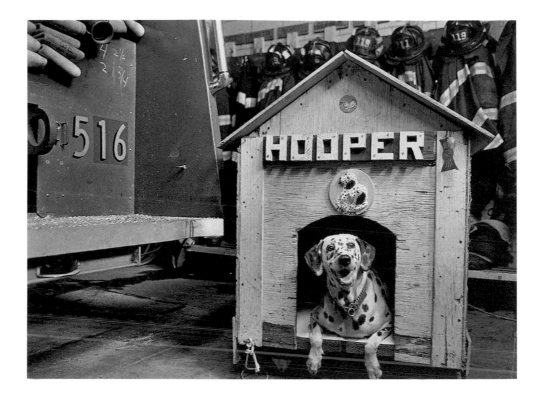

Engine Co. 211 (dalmatian)

Hooper, the much-loved mascot of
this Brooklyn firehouse, frequently
visits local classrooms to teach
kids life-saving techniques, like
how to "stop, drop, and roll."
(dalmatian)

maxine

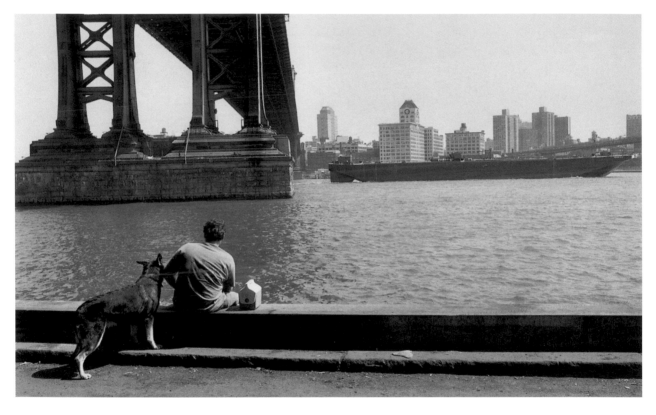

Lunch break under the Manhattan

Bridge (German shepherd)

benno

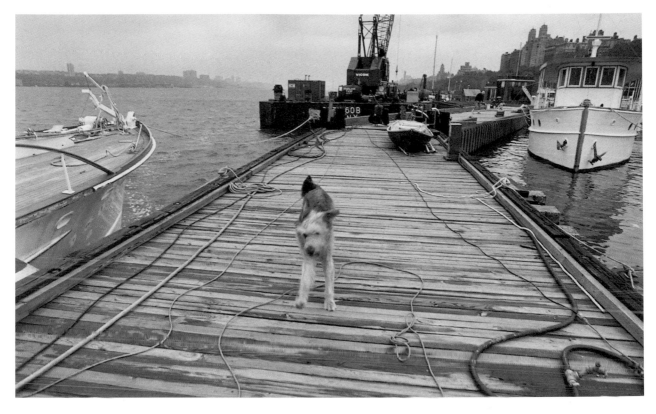

Benno, 79th Street Boat Basin,

Hudson River (mix)

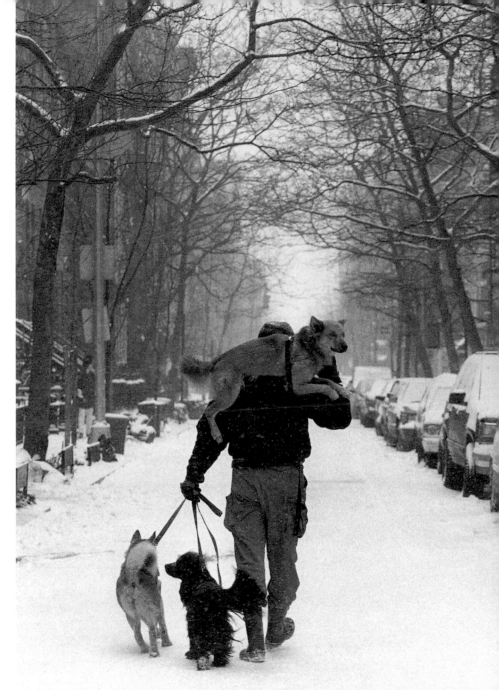

Perry Street, Manhattan (clock-
wise from top: Samarkand husky,
Field spaniel, and Siberian husky)

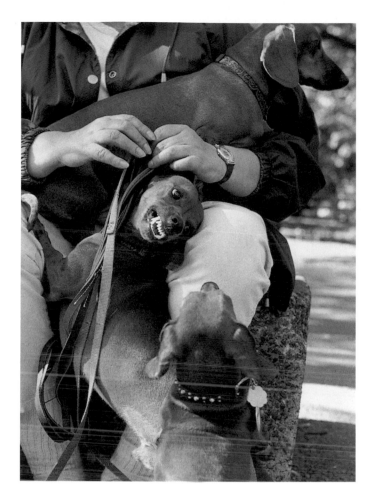

The Dachshund Octoberfest hosted
by the Dachshund Friendship Club,
Washington Square Park
(dachshunds)

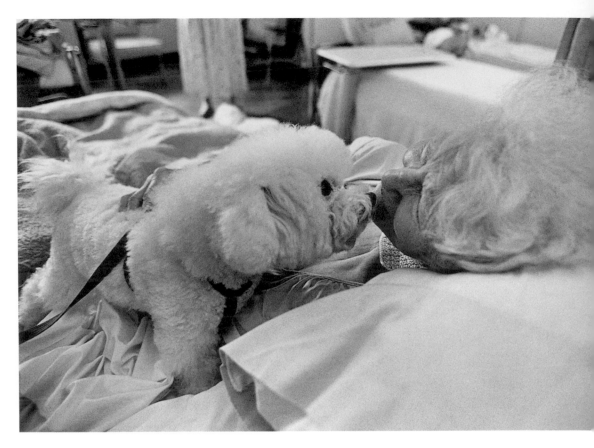

winnie

Fieldston Lodge Nursing Home,
the Bronx (Bichon frise)

As one of Toni Tucker's therapy
dogs, Winnie brings a little light
into the lives of hospital patients.
This stroke victim was able to
communicate her joy after a few
of Winnie's dainty kisses.

winston

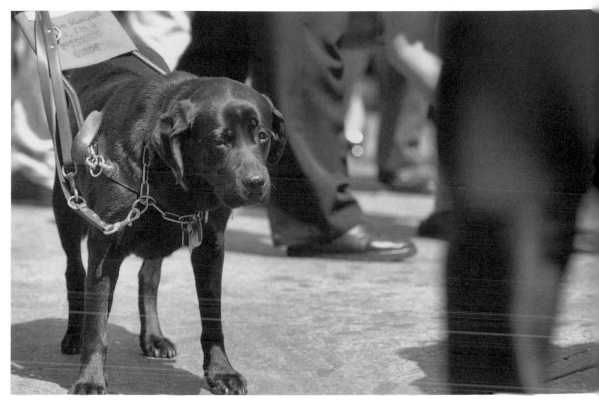

Winston, guide dog par excellence
and world traveler, Court Street,
Brooklyn (black Labrador
retriever)

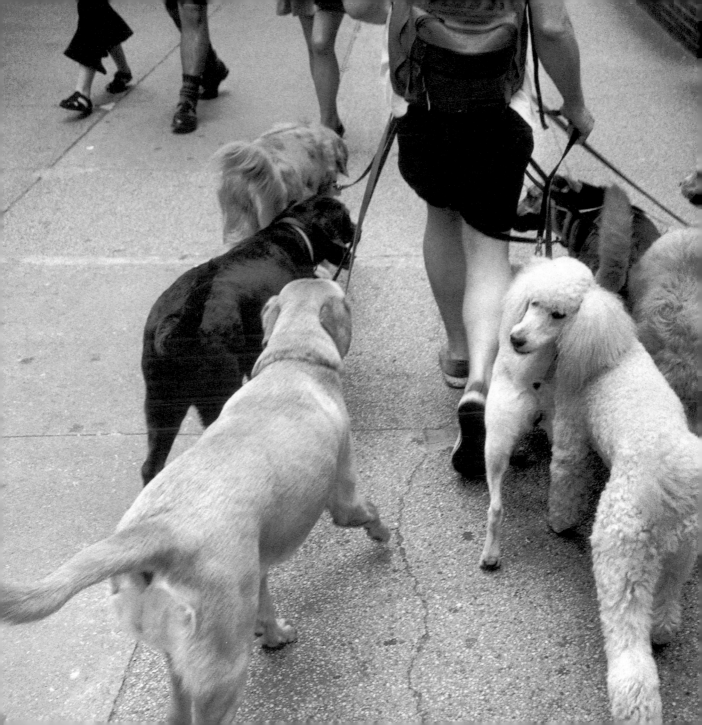

sadie

Sadie steps out with the K-9 Club,
Inc., dogwalkers, Upper East Side
(center: poodle, others: various)

tagio

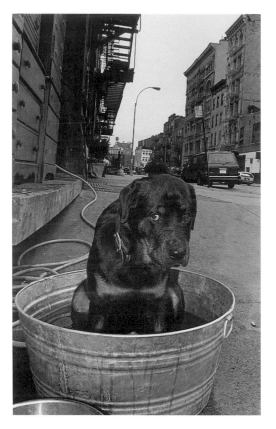

Tagio cooling off, Bond Street,

East Village (rottweiler)